Corinium Museum
highlights

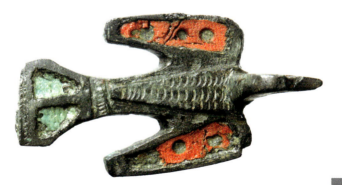

S
C
A
L
A

THE CORINIUM MUSEUM – A BRIEF HISTORY

The first Corinium Museum was built by the 4th Earl Bathurst to house two mosaics, the Hunting Dogs and the Seasons, which were discovered in 1849 during sewerage works in the town. The building, no longer a museum, still stands in Tetbury Road today. The Bathurst Collection was given to the town in 1936, together with the Cripps Collection, to form the second Corinium Museum and the first one to be established on the present site in Park Street. The new purpose-built museum was erected in the grounds of Abberley House, a grade II-listed building, and was opened in 1938. Since then it has undergone several developments, including a major Heritage Lottery-funded project in 2002–4.

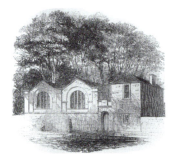

An engraving of the first Corinium Museum
In 1856 the 4th Earl Bathurst had a museum built into the wall of Cirencester Park to house his collections of antiquities. This was open daily to the public.

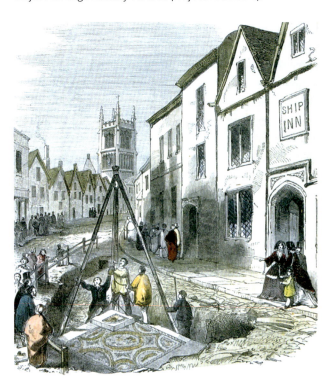

The museum entrance
A photograph taken after it opened in Park Street in 1938.

An engraving showing the lifting of the Huntings Dogs Mosaic
The Hunting Dogs pavement was found, together with the Seasons Mosaic, in Dyer Street, Cirencester, in 1849.

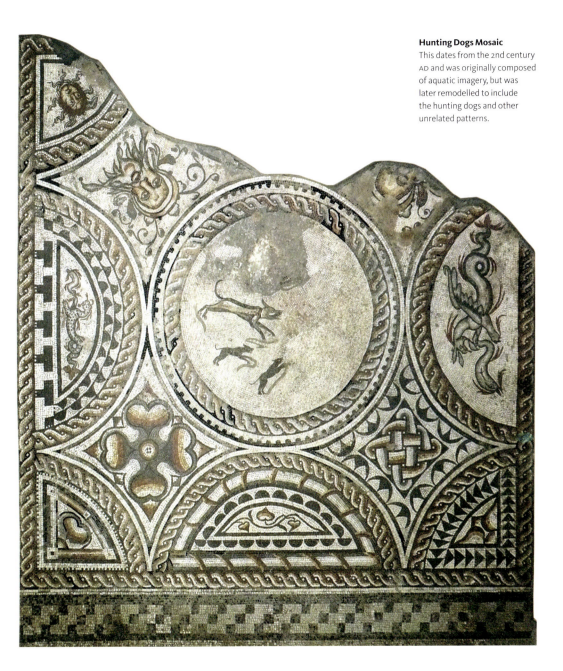

Hunting Dogs Mosaic
This dates from the 2nd century AD and was originally composed of aquatic imagery, but was later remodelled to include the hunting dogs and other unrelated patterns.

THE PREHISTORIC PERIOD

The earliest prehistoric people arrived in the Cotswolds from around 700,000 years ago. They lived as nomadic hunter-gatherers, but over thousands of years ways of life changed and the first farmers emerged, living in recognisable settlements. These early inhabitants left behind a rich archaeological past, including human and animal remains, stone tools and, later on, fine metal tools and weapons.

Palaeolithic (1,000,000–10,000 BC)

During the Palaeolithic period our ancestors survived by hunting animals, fishing and gathering plants. They also began to fashion multi-purpose stone tools and implements, most commonly flint handaxes which were used for chopping and cutting.

Mesolithic (10,000–4000 BC)

By 6000 BC Britain had become an island and the Cotswolds were mostly woodland. People roamed across far smaller territories, indicating a more settled way of life. During this period tool technology advanced and spear-like implements, fishing barbs, harpoons and fine blades were fashioned.

Neolithic (4000–2500 BC)

From about 4000 BC plants and animals started to be domesticated. In Britain handmade pottery also emerged, which was bonfire-fired and of local manufacture.

The people of the Neolithic period laid out their dead in large burial monuments known as long barrows. Hazleton North, near Northleach, was excavated between 1979 and 1982. It comprised two chambered areas that contained over 9,000 bone fragments, representing at least 23 skeletons.

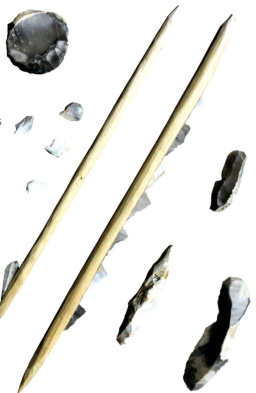

Palaeolithic handaxe
Found during gravel extraction in South Cerney, near Cirencester. This tool is over a quarter of a million years old.

Mesolithic tools
A group of small, narrow flint blades, or microliths, and scrapers.

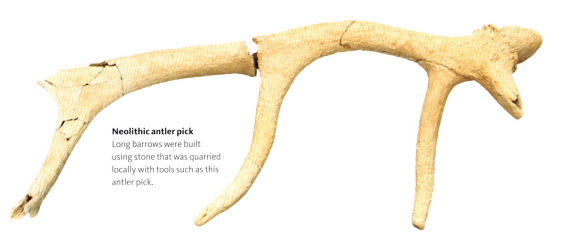

Neolithic antler pick
Long barrows were built using stone that was quarried locally with tools such as this antler pick.

Bronze Age (2500–700 BC)

From about 2500 BC a major technological change occurred with the introduction of metalworking.

As skills developed, a wide range of weapons and tools was produced, such as axes, knives, spears and daggers, as well as personal ornaments including rings, beads, pins and bracelets.

Through the later Neolithic and early Bronze Age individual burials start to appear under circular mounds known as 'round barrows'. Pottery beakers are frequently found in these graves. The vessels are often decorated with geometric patterns arranged in horizontal zones, the impressions applied using cord, twigs or small pieces of bone.

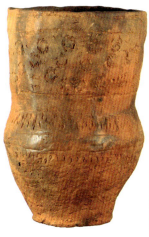

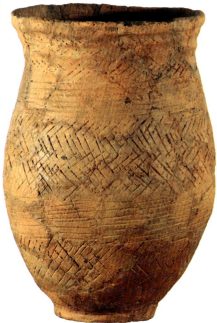

Beakers, late 3rd millennium BC
A pair of decorated beakers excavated from Lechlade in 1995. Both beakers accompanied burials.

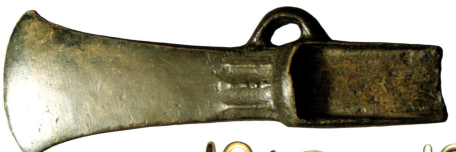

Early Bronze Age axe
This is a type of axe known as a palstave.

Late Bronze Age gold bead
A necklace of similar beads from Ireland, now at the British Museum, and a single bead from Suffolk are the only other recorded finds.

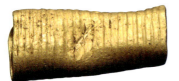

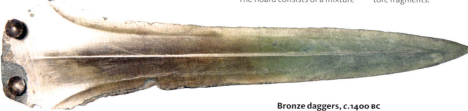

Bronze Age gold hoard
Unearthed in 2004 from Poulton, near Cirencester. The hoard consists of a mixture of complete and deliberately broken items of jewellery, including rings, bracelets and torc fragments.

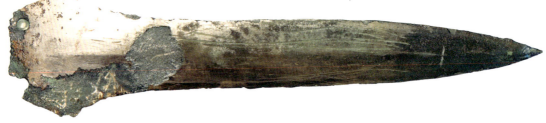

Bronze daggers, c.1400 BC
A striking pair of bronze daggers was found near Fairford, probably placed originally in a round barrow. Such finds clearly indicate the important social status of the owner.

Iron Age (700 BC–AD 43)

Around 700 BC the peoples of Britain began to use iron rather than bronze for tools and weapons. Across the Cotswolds the landscape was densely settled and intensively farmed from the middle Iron Age to the early Roman period. The economy was equally sophisticated, with evidence of salt and pottery being widely traded, and ironworking and the minting of coins taking place.

The art produced in Britain during the Iron Age is very different from that found in the contemporary classical Mediterranean world. Classical decorative motifs were adapted, resulting in a more stylised and abstract art form. This can be seen applied to the metalwork on objects such as weapons, horse fittings, mirrors, shields and tankards.

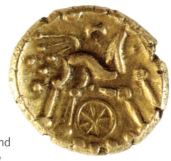

Gold coin

A late Iron Age gold coin, or stater, depicting a triple-tailed horse. The area around Lechlade and Fairford seems to have been used for large-scale horse-rearing prior to the Roman invasion.

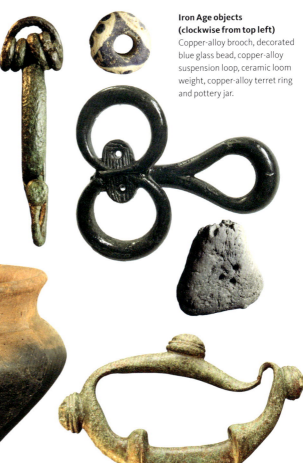

Iron Age objects (clockwise from top left)

Copper-alloy brooch, decorated blue glass bead, copper-alloy suspension loop, ceramic loom weight, copper-alloy terret ring and pottery jar.

The Coming of the Romans

A fort was established in Cirencester within a year of the Roman conquest of Britain in AD 43. It housed a cavalry unit of 500 men. Evidence for the garrison comes from stray finds of military equipment and two exceptionally fine military tombstones. By AD 75 the Roman fort had been dismantled and the troops transferred elsewhere.

Samian bowl
Decorated with leaves and vines, this bowl was found during excavations of the Leaholme fort in 1961. Samian is a type of orange glossy decorated fine tableware that was used to serve food.

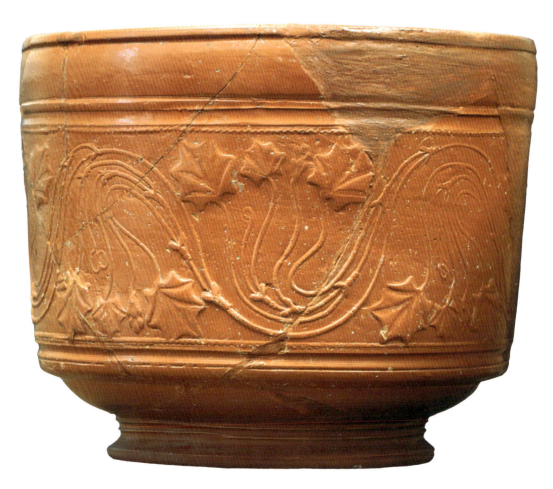

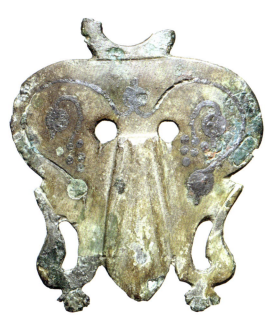

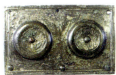

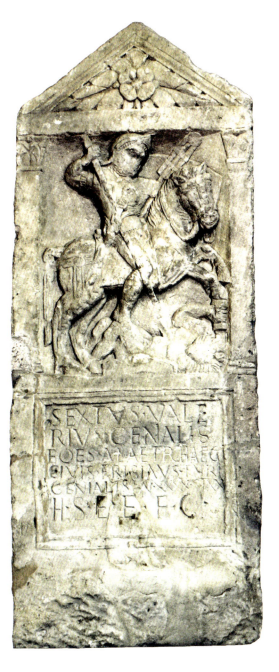

ABOVE: **Horse harness pendant**
Copper-alloy military horse harness pendant dating from the 1st century AD, found at St Michael's Field in 1974.

LEFT: **Saddle plates**
A rare set of decorated military saddle plates from Cirencester. They were used to decorate horse harnesses for parade purposes.

Military tombstone
A cavalry tombstone of Sextus Valerius Genialis, dating from the 1st century AD.

ROMAN CIRENCESTER

Corinium Dobunnorum, Roman Cirencester, was the second largest town in Roman Britain. After the army left, the civilian settlement, or *vicus*, which had built up in the vicinity of the fort, was remodelled. In the centre of the town stood the main public buildings and the Basilica Forum complex. By the third century AD the town was equipped with walls and monumental gateways.

The largest and wealthiest houses had hypocaust heating systems, painted wall plaster and mosaics. Corinium was home to several important artists' workshops: there is evidence for metalworking, quarrying, tile-making, leather-working, woodworking, weaving and bone-working. It is likely that the town was also home to a group of highly skilled sculptors.

Eye
Leaded copper-alloy eye from a statue found during the excavations at the Basilica in 1898.

Finger
Copper-alloy fingertip fragment from a statue found at Lewis Lane in 2006.

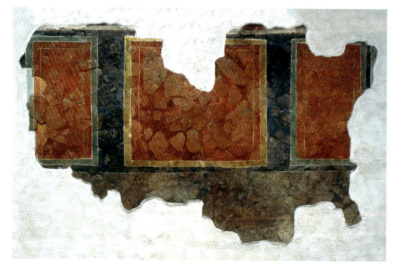

Wall plaster
Large section of painted wall plaster from a 1st-century AD timber-framed shop.

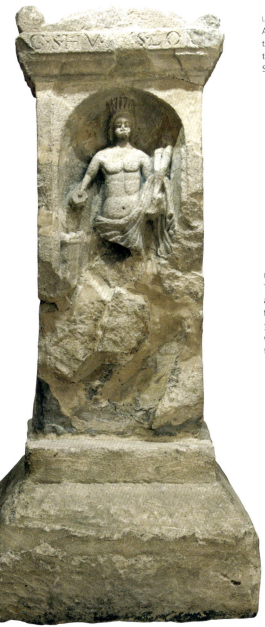

LEFT: Altar
A stone altar dedicated to the Genius Loci, 'Spirit of the Place', found in Sheep Street in 1880.

BELOW: A fragment of an inscription
From a major public building in Roman Cirencester, found at the Beeches Road townhouse. It records the two senior local magistrates, the *duoviri iuricundi*.

BELOW: Corinthian capital
This once formed part of a 'Jupiter column', dating from the late 2nd or early 3rd century AD, which would have once stood in the forum at the centre of Roman Corinium. Bacchus, the god of wine, is clearly recognisable here from the two bunches of grapes either side of his head. It was found in an area known as the Leauses, Cirencester, in 1838.

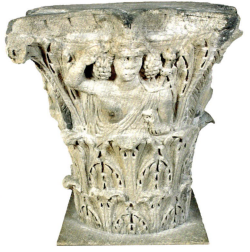

Roman Mosaics

The most famous artists' workshop was the Corinium School of Mosaicists. Two mosaics produced there, the Seasons and Hunting Dog, are among the earliest and most accomplished pavements found in Britain. The Seasons Mosaic, dating from the second century AD, was originally composed of nine octagons, only five of which survive, each containing a figurative panel.

Seasons Mosaic: Actaeon
The scene shows Actaeon being transformed into a stag, about to be devoured by his own dogs, as a punishment for having seen the goddess Diana bathing.

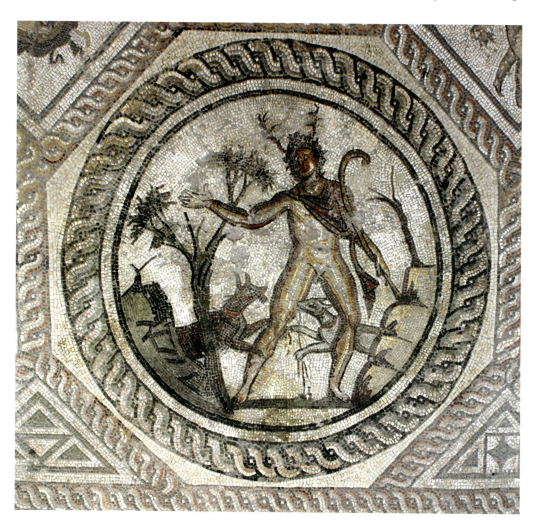

Seasons Mosaic: Spring
Wearing a headdress of flowers and leaves, with a swallow perched on her left shoulder.

Seasons Mosaic: Summer
With a sickle across her right shoulder and two ears of corn across her left.

Seasons Mosaic: Autumn
Wearing a leopard-skin tunic, with a pruning knife across her right shoulder.

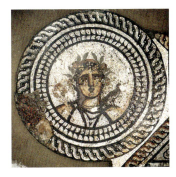

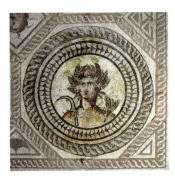

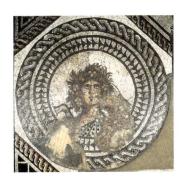

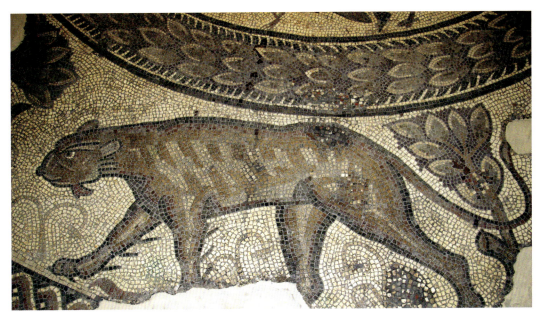

Orpheus Mosaic: a lioness
Found in 1825 at Barton Farm in Cirencester Park. Dating from the first half of the 4th century AD, the mosaic depicts Orpheus at its centre encircled by birds and beasts that have been enchanted by his music.

The People of Corinium

People in Roman Britain were very fashion-conscious and spent a lot of time and effort on their appearance. Keeping up with the latest trends in hairstyle and make-up would have been considered important. Jewellery was worn by men, women and children, and included bracelets, necklaces, brooches and finger-rings.

Earring
A gold earring set with turquoise stone and pearl beads. Found during excavations at the police station, Cirencester, in 1962.

Earring
Gold annular earring found in Long Newnton, near Tetbury, in 2011.

ABOVE: **Ring**
Copper-alloy finger-ring, which doubled as a key, used to open small caskets. Found during excavations at Ashcroft, Cirencester, in 1951.

LEFT AND ABOVE: **Copper-alloy brooches**
The brooch in the shape of a bird, decorated with blue and red enamel, was found during excavations at the amphitheatre in 1966. The other, representing a horse and rider, was found during excavations in Watermoor Road, Cirencester, in 1990.

Cup

Hunt cup showing a hound chasing a deer. Beakers like this were very expensive and fashionable tablewares. Found during excavations at Leaholme, Cirencester, in 1961.

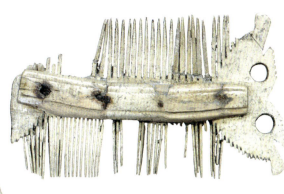

Comb

Double-sided bone comb with one end made to look like the face of an owl. Found during excavations at Bath Gate cemetery in 1972.

BELOW: **Knife**

Clasp knife with iron blade and copper-alloy handle showing a hound chasing a hare. Hunting, especially with dogs, was a popular pastime. Found during excavations at Bath Gate cemetery in 1971.

ABOVE: **Hairpin**

Copper-alloy hairpin decorated with enamel, found at the Beeches Road townhouse in 1973.

Roman Religion

Religion was an important part of everyday life. Gods and goddesses were worshipped in temples and in the home. The Romans introduced the worship of the classical gods, such as Jupiter, Diana and Minerva, to Britain, but the worship of local deities also continued to flourish. One of the most popular local cults was that of the mother goddesses or Sulivae. They are often shown with three hooded male spirits, the Genii Cucullati, who probably represent guardian spirits of the local area.

LEFT: Diana
Copper-alloy figurine of the Roman goddess of hunting, shown pulling an arrow out of her quiver.

Vulcan
Copper-alloy head of the Roman god of fire and volcanoes.

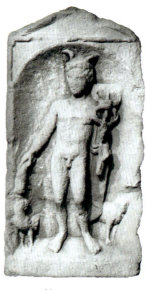

BELOW: Cockerel
Silver figurine of a cockerel with gilt wings, tail and comb. Found during excavations at Watermoor School, Cirencester, in 1967.

ABOVE: Mercury
The messenger of the gods is often accompanied by a cockerel (bottom left). Many figurines of Mercury have been found, suggesting that he was a popular god in Corinium. Found at the Leauses in the 1850s.

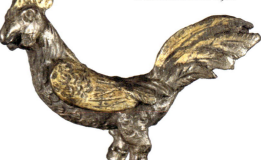

RIGHT: **Acrostic**

This famous graffito was scratched on to the surface of a piece of 2nd-century wall plaster, found during excavations of a Roman house in Victoria Road, Cirencester, in 1868. The acrostic, or word-square, reads:

```
R O T A S
O P E R A
T E N E T
A R E P O
S A T O R
```

It is generally believed to be a secret Christian code, dating from a period of persecution, though some consider it to be nothing more than a clever word game.

Water nymph

Bone figurine of a water nymph, a symbol of spring.

BELOW: **Genii Cucullati**

Votive relief depicting three hooded spirits and a seated goddess. Found during the building of the new police station, Cirencester, in 1964.

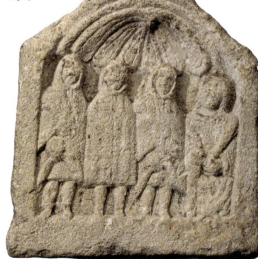

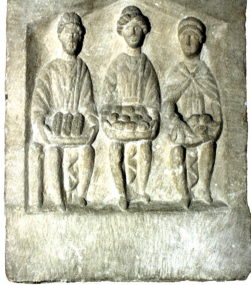

Mother goddesses

This sculpture of the Sulivae was found in Ashcroft, Cirencester, in 1899.

Burying the Dead

Under Roman law it was forbidden to bury the dead inside the walls of the town. Discoveries since the nineteenth century and as recent as 2011 confirm that the largest cemetery was positioned immediately outside and to the west of the Bath Gate.

Inscribed tombstones are a fascinating source of information, but only the richest citizens of Corinium would have been able to afford them. They can reveal names, ages, occupations and where people came from.

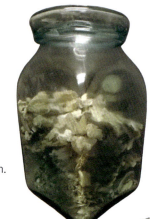

Glass cinerary urn
Found at King's Mead, Cirencester, c.1765, in what may have been a mausoleum. This glass vessel contains cremated remains.

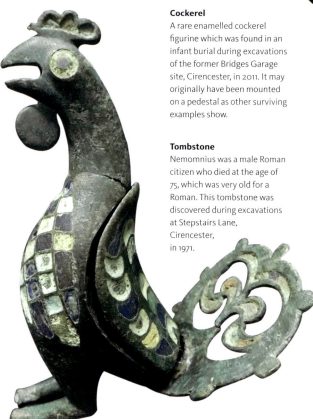

Cockerel
A rare enamelled cockerel figurine which was found in an infant burial during excavations of the former Bridges Garage site, Cirencester, in 2011. It may originally have been mounted on a pedestal as other surviving examples show.

Tombstone
Nemomnius was a male Roman citizen who died at the age of 75, which was very old for a Roman. This tombstone was discovered during excavations at Stepstairs Lane, Cirencester, in 1971.

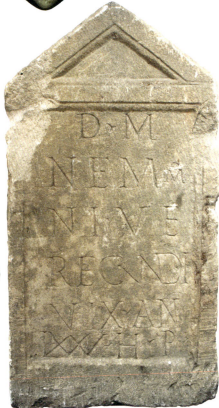

The End of Roman Corinium

Corinium grew to become an important town as a provincial capital. At the beginning of the fourth century the Roman Empire was divided into 12 regions, which were then subdivided into provinces. Britain was divided into four provinces, with capitals at London, Lincoln, York and Cirencester. Corinium was the capital of Britannia Prima, which encompassed the whole of south-western Britain.

The fourth century AD was a period of great prosperity for Corinium; the population peaked and many buildings were remodelled. However, the collapse of the Roman Empire had far-reaching effects. Corinium was dependent on the political and economic structures of Rome, so once these were taken away the town fell into decline.

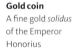

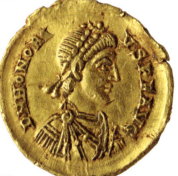

Gold coin
A fine gold *solidus* of the Emperor Honorius (r.AD 383–423).

ABOVE: **Septimius stone**
This inscription records the restoration of a Jupiter column in the town by Lucius Septimius, who is described as the *rector*, or governor, of the Province of Britannia Prima. Found in Victoria Road, Cirencester, in 1910.

Flask
This vessel contained the Tetbury coin hoard, which was found in 2010. The coins range in date from AD 260 to 280, a period of political turmoil in the Roman Empire.

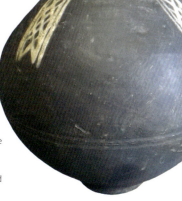

Gold coin
A rare gold *aureus* of the Emperor Carausius (r.AD 287–293). The obverse bears a rather thug-like portrait of the emperor – presumably how he wished to be portrayed.

THE ANGLO-SAXONS IN THE COTSWOLDS

From the fifth century, Saxons from north-west Germany seem to have been the main settlers in the Thames Valley, from where they spread to the Cotswold Hills. Part of a large settlement has been discovered in Lechlade, where excavations have revealed six small buildings, either houses or workshops, with sunken floors. This suggests a modest community surviving on its local resources, in complete contrast to the exotic wealth of their burials.

The early Anglo-Saxons were pagan and buried their dead with grave goods. Most of our knowledge about them comes from excavations of their cemeteries, such as those at Fairford, Cirencester and Kemble. The largest and most important of these excavated sites is, however, the cemetery at Butler's Field, Lechlade, which contained the remains of 248 men, women and children. It was in continuous use from the late fifth to the early eighth centuries, a time when Christianity was becoming the dominant religion in England. It is the only Anglo-Saxon cemetery in the Thames Valley where pagan and Christian burials occupy the same site.

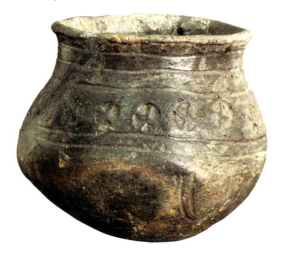

LEFT: **Ceramic pot**
A handmade pot with stamped decoration, found in a grave at Barton Farm just outside Cirencester.

ABOVE: **Objects from the grave of a young male**
The young man, who was 16–18 years old, was buried some time between 475 and 550 with a shield, two spears, a knife and a cauldron.

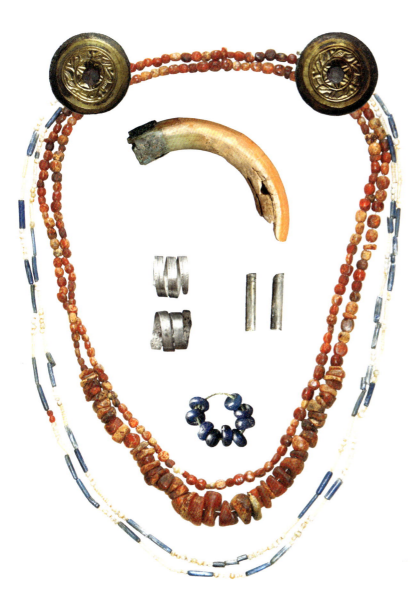

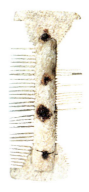

Objects from the grave of a young woman

The deceased, who lived in the 6th century, was 25–30 years old. Her grave goods included a large bronze decorated square-headed brooch, two bronze decorated saucer brooches, two silver spiral rings, an amber necklace, a blue glass and bone beaded necklace, a beaver's tooth pendant, hair decorations and a bone comb.

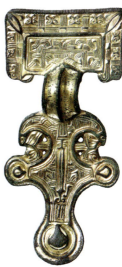

Late Anglo-Saxon Cirencester

At first the Anglo-Saxons of Lechlade maintained links with their homelands. The huge quantity of Baltic amber beads in the sixth-century graves testifies to a continuing trade between the Cotswolds and Scandinavia. Likewise, finds of a number of metal bowls and cauldrons from the Rhineland hint at links with northern Germany. During the next century the pattern of trade altered: the seventh-century graves contain luxury goods such as cowrie shells and objects decorated with garnets and amethysts, indicating trade with the Mediterranean, which in turn gave access to goods from the Indian Ocean.

In the late Anglo-Saxon period Cirencester became the centre of a royal estate, where the king occasionally held his council. In 999 Ethelred the Unready, king of England (978–1013 and 1014–1016), issued a charter from Cirencester ordering the banishment of an important local earl, Aelfric, for an unspecified crime; and at Easter in 1020 King Cnut (c.985/995–1035) held a Great Council in the town.

Gold pendants

These four rare and beautiful gold pendants were found in graves at Butler's Field Anglo-Saxon cemetery and date from the 7th century. Two were found with women aged 35–40 and two with young children aged 2–4 years old.

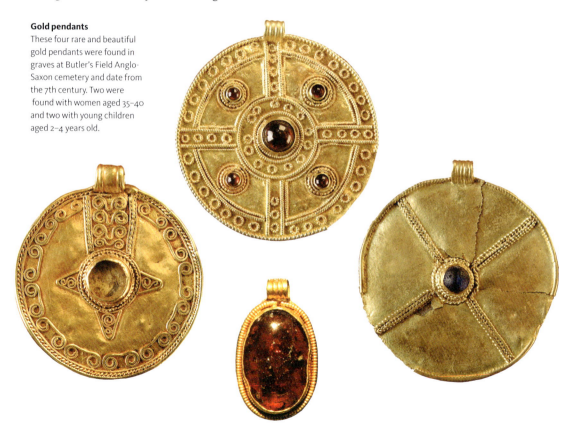

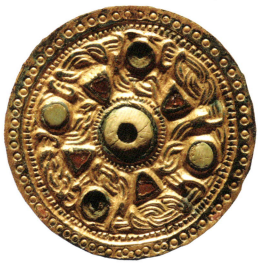

ABOVE: **Gilt-bronze keystone garnet disc brooch**
Four triangular insets of garnets and four circular and one large central circular setting of shell. Found in the grave of a child aged 4–5 years old.

BELOW: **The 'Tunley Torc'**
A 9th- or early 10th-century plaited Anglo-Norse ring found at Tunley, Gloucestershire.

ABOVE: **King Alfred coin**
A silver penny from the reign of Alfred, king of Wessex (849–899), found in Coberley, Gloucestershire.

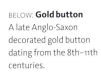

BELOW: **Gold button**
A late Anglo-Saxon decorated gold button dating from the 8th–11th centuries.

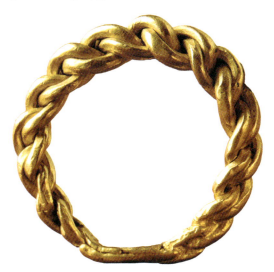

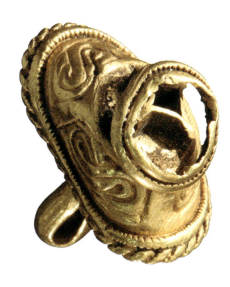

MEDIEVAL CIRENCESTER

The Norman Conquest in 1066 had little immediate effect on the Cotswolds. Cirencester remained a royal estate and a market was granted to the manor in 1086; over the next 300 years Cirencester changed from being a farming community to a centre of bustling trade.

Throughout the twelfth and thirteenth centuries the English wool trade flourished and Cotswold wool became much sought after. The most important industry in the town was the manufacture of woollen cloth. Fine churches and cathedrals were built with money earned from the wool trade and many abbeys had their own flocks of sheep.

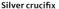

Silver crucifix
Silver-gilt medieval pendant crucifix, with Christ suspended from the Cross, flanked by the Virgin Mary on his right side and John the Evangelist on his left. Found at Stowell Park, Yanworth.

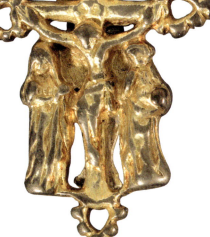

LEFT: **Gold noble**
A quarter rose gold noble of Edward III (r.1330–1377) found at Barton Farm, Cirencester. During the 14th century a gold exchange was established in Cirencester marketplace next to the Boothall, on the site of the present Corn Hall.

RIGHT: **Lead bulla**
Medieval lead papal bulla from the reign of Pope John XII (1316–34), found during Cirencester Abbey and Saxon Church excavations, 1964–66. Papal bulls – formal proclamations issued by the Pope – were sealed with leaden bullae such as this. The heads of St Peter and St Paul can be seen on the reverse with the inscription SPA [St Paul] SPE [St Peter].

Lead star
Thought to be ceiling decoration, this would once have been gilded and may have been intended to mirror the heavens inside the Abbey of St Mary. Found during excavations on the site of Cirencester Abbey and Saxon Church, 1964–66.

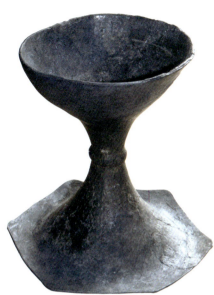

LEFT: **Lead ampulla**
Ampullae were bought by pilgrims from religious sites. They were used to carry holy water or oil to promote health benefits, or to elicit a good harvest if poured or buried on the land.

Pewter chalice
Dating from the 14th century, this example was found in a burial during excavations on the site of Cirencester Abbey and Saxon Church, 1964–66. The chalice is one of the sacred vessels of the Church, used to hold the Communion wine.

Pope and abbot
Excavations carried out in the abbey grounds in 1964–66 revealed the plan of the church and a wealth of broken sculpture from the chapter house, including these 15th-century abbot's and pope's heads. The quality of the workmanship hints at the lost glories of the abbey and its buildings.

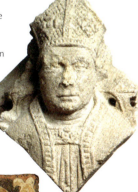

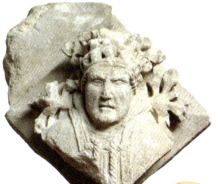

Medieval tile
Tiles like this have been found at the site of Cirencester Abbey. Many have inlaid slip decoration depicting flora, birds, fleurs-de-lys, script, heraldic devices, buildings and animals.

Grotesque face
This medieval carved stone corbel is in the form of a grotesque head with its tongue sticking out. Grotesque carvings were part of the Church's way of communicating its stories and beliefs to a largely illiterate population.

Building work began on the great Augustinian Abbey of St Mary in 1117 and continued unabated until 1539, when King Henry VIII (r.1509–1547) ordered it to be dissolved and destroyed – a clear message articulating England's break with the Roman Catholic Church. Little now remains of the abbey, but excavations in the 1960s uncovered a number of objects that attest to its former magnificence and hint at aspects of medieval daily life.

The accession of Elizabeth I in 1558 heralded a period of relative peace and prosperity in the later Tudor period. Trade in Cirencester expanded once again, with woollen manufacturers and merchants bringing affluence to the town and surrounding areas. Investment from trade encouraged growth in the town and the markets continued throughout the medieval period up to the present day.

Ivory figurine
The goods offered for sale in the market at Cirencester became quite exotic as trade expanded. This elephant-ivory knife handle in the form of a lady with a hawk was probably traded in the market place. It was found in the Old Ship Inn, Dyer Street, Cirencester, in 1900.

Bone earscoop
Earscoops were used to clear wax from the ear. This 14th-century example is carved in the form of a monk, the details of his clothing and face clear and well executed.

Tripod cistern
An example of simple everyday pottery used for storing and pouring liquid.

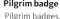

Pilgrim badge
Pilgrim badges, often mass-produced in pewter or base metal, were collected at religious sites. This 15th-century copper-alloy example depicts the Passion. It was found during excavations of the site of Cirencester Abbey and Saxon Church, 1964–66.

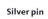

Silver pin
A close up of the head of a silver pin dating from the 16th century, worn as an adornment to clothing.

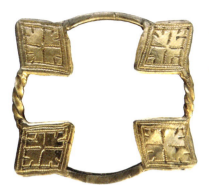

LEFT: **Medieval brooch**
A silver-gilt brooch that would have been worn to secure and adorn clothing. Late 13th to early 14th centuries.

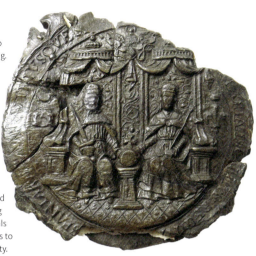

Tudor seal
Tudor royal seal portraying Queen Mary 1 and Philip of Spain (r.1554–1558) seated on their thrones, holding a sword and sceptre. Seals were used on documents to validate their authenticity.

Henry VIII coin
A silver groat depicting Henry VIII (r.1509–1547).

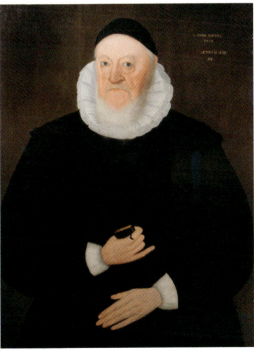

Portrait of John Coxwell (1516–1614)
John Coxwell made his money from the wool trade. He purchased lands in and around Cirencester as his wealth grew: Coxwell Street in Cirencester is one of his legacies in the town.

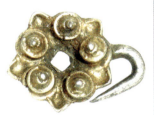

Tudor dress-hook
As the rising middle classes established themselves socially, they started to imitate courtly styles. This silver-gilt dress-hook, found at Northleach, is typical of the period and of the desire for conspicuous consumption while not falling foul of Elizabethan 'sumptuary laws' (dress codes).

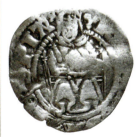

Thomas Wolsey coin
Thomas Wolsey (c.1475–1530), best known as Cardinal Wolsey, was responsible for shutting down a number of religious houses in England, with the blessing of the Pope.

THE CIVIL WAR AND CIRENCESTER

At the beginning of the seventeenth century the Cotswolds saw an economic decline which brought with it social unrest. The wool trade collapsed, war raged on the Continent and irresponsible royal fiscal policies had a long-lasting impact on the people of Cirencester, who depended on the wool trade for their livelihood.

By the 1630s political and religious opinion in Gloucestershire was increasingly polarised and there was open opposition to the personal rule of Charles I (r.1625–1649). When war finally broke out between the king and Parliament in 1642, the kingdom was plunged into turmoil. The people of Cirencester, led by a number of prominent citizens, declared for Parliament and established a formidable garrison. Owing to its strategic central position the Cotswolds was fought over throughout the Civil War, and Cirencester, at the junction of three major roads, was the key to its control.

On 2 February 1643 Prince Rupert launched a successful attack on the town. Over 300 defenders were killed and 1,200 prisoners were taken and marched to prison in Oxford. The town was ransacked and wool, cattle, sheep and horses were seized. The war brought financial ruin to many in Gloucestershire and near-famine conditions to parts of the county.

THE
PETITION
OF THE
Inhabitants of CYRENCESTER,
whose names are hereunto
subscribed.

Presented to His MAJESTY
at OXFORD.

WITH
HIS MAJESTIES
Answer thereunto.

Printed, by His MAJESTIES command
At OXFORD, Febr. 28.
By LEONARD LICHFIELD, Printer
to the University. 1642.

A Civil War pamphlet
A contemporary copy of the petition for clemency presented to the king on behalf of the people of Cirencester. It contains the names of many prominent townsfolk and was printed at the express order of the king in 1643.

A carved shale silhouette of Endymion Porter
Endymion Porter (1587–1649) was an important Royalist, a courtier and friend of Charles I. He was born in Mickleton and lived at Aston sub Edge near Chipping Campden. Porter was a patron of the arts and helped found the royal art collection.

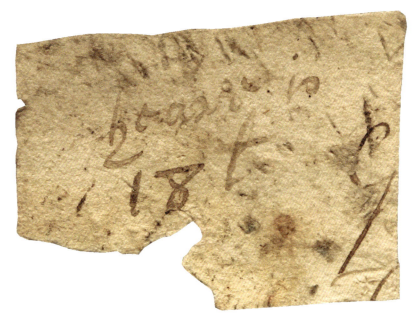

The Weston sub Edge Hoard

This large and important Civil War hoard consists of 307 silver and 2 gold coins. It was found under the floor of a former barn in Weston sub Edge in 1981. The coins were contained in a specially made lead pipe and were accompanied by a scrap of paper (left) which declared 'Ye Hoard is £18'. The person who buried this money never made it back to collect it.

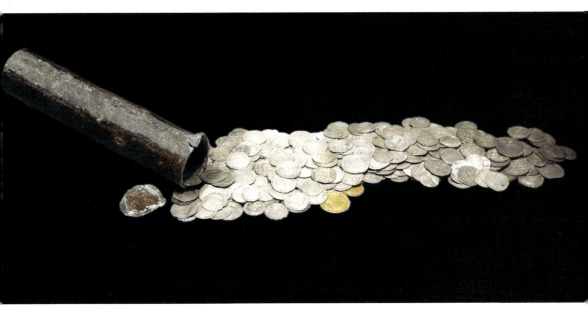

EIGHTEENTH- AND NINETEENTH-CENTURY CIRENCESTER

Cirencester had recovered from the effects of the Civil War by the early eighteenth century, as had its major industry the wool trade. However, by the late eighteenth century cloth manufacture was concentrated in the Stroud valleys, on sites with easy access to water to power the mills. Inevitably trade in Cirencester declined, with only New Mills continuing to operate into the early nineteenth century. The dwindling cloth trade was replaced with the manufacture of tools for agricultural implements and machinery, and a mixed farming economy.

 The Industrial Revolution arrived in Cirencester by canal, the Cirencester arm of the Thames and Severn Canal opening in 1789. The eighteenth century also saw the first publication of the Cirencester Flying Post, the playing of a new sport, cricket, and the opening of a theatre in Gloucester Street.

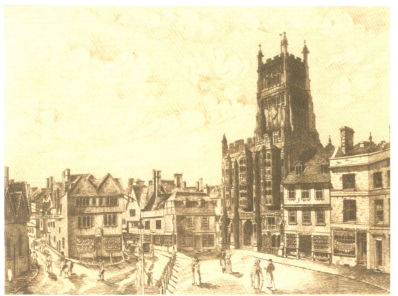

Mourning ring
An exquisite gold and enamel mourning ring, inscribed Elizabeth Lodge and dated January 1776.

Engraving of the Market Place by J. Evans, 1805
This shows the Shambles and the shops, houses and lanes which had encumbered the middle of the Market Place since the late 13th century.

Through the nineteenth century Cirencester doubled in size and population. As the town developed, the processing of locally produced goods came to be an important factor. The Corn Hall opened in 1862, enabling the corn dealers to transact their business under cover for the first time. As commerce expanded, so did the accompanying infrastructure, with a number of private and commercial banks being founded at the end of the century.

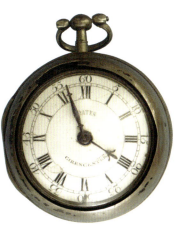

A cased silver pocket watch
This watch was made by Coates of Cirencester, a maker noted for the high quality of his workmanship. Coates appears to have had premises in Dyer Street, Cirencester. The case is inscribed with the owner's name, Francis Gibbs, and the date, 1771.

Engraving by Johannes Kip, 1712
'Cirencester the Seat of Allen Bathurst Esq.'.

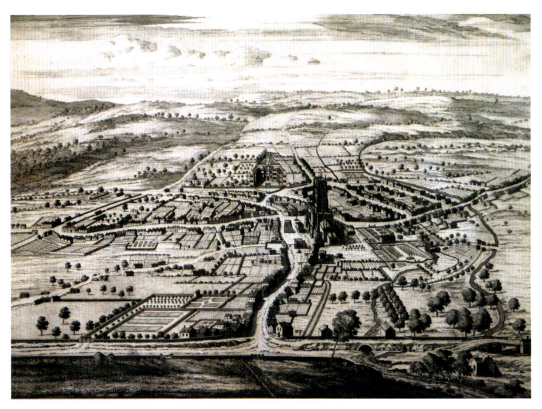

First published in 2015 by
Scala Arts & Heritage Publishers Ltd
10 Lion Yard
Tremadoc Road
London SW4 7NQ, UK
www.scalapublishers.com

In association with
Corinium Museum
Park Street
Cirencester
Gloucestershire GL7 2BX
www.coriniummuseum.org

ISBN 978-1-85759-936-7

Edited by Laura Lappin
Designed by Nigel Soper
Printed in Turkey

10 9 8 7 6 5 4 3 2 1

FRONT COVER: Seasons Mosaic: Summer, Roman, 2nd century AD.
BACK COVER: Gold pendant with inlaid garnets, Anglo-Saxon, 7th century.
FRONT FLAP: Enamelled cockerel figurine, Roman, 2nd century AD.
BACK FLAP: Corinium Museum, Cirencester.
INSIDE FRONT COVER: Hunting Dogs Mosaic, Roman, 2nd century AD.
INSIDE BACK COVER: Septimius stone, Roman, 4th century AD.